RUDE COCKTAILS

Photographed by David Thorpe
Written by Pierre Le Poste. Designed by Martin Reavley

M
MACMILLAN LONDON

RUDE™

COPYRIGHT © RUDEMENTARY CONCEPTS LIMITED 1983

TYPOGRAPHY NIGEL KENT

STUDIO ASSISTANT IAN KALINOWSKI

STYLIST SARAH HARRINGTON

DRINKS MIXED BY CHRISTOPHER HOLT

WE SHOULD LIKE TO THANK THE FOLLOWING FOR THEIR
GENEROSITY IN SUPPLYING WARDROBE AND PROPS

BEGED-OR: BROWN'S OF SOUTH MOLTON STREET;
THE COCKTAIL SHOP, NEAL STREET, LONDON WC2;
MICHAEL DRUITT WINES LIMITED; JOHN MILROY WINES & SPIRITS; ROBERT GALLAGHER.

TEXT AND ILLUSTRATIONS COPYRIGHT © DAVID THORPE 1983

ISBN 0 333 36050 8 cased
ISBN 0 333 36051 6 paperback

FIRST PUBLISHED 1983 BY
MACMILLAN LONDON LIMITED
LONDON AND BASINGSTOKE
ASSOCIATED COMPANIES IN AUCKLAND, DALLAS, DELHI, DUBLIN,
HONG KONG, JOHANNESBURG, LAGOS, MANZINI, MELBOURNE,
NAIROBI, NEW YORK, SINGAPORE, TOKYO, WASHINGTON AND ZARIA

PRINTED IN HONG KONG

26 intoxicating recipes
from the authors of
VIN RUDE

Cocktails for two,
photographed through frosty glasses by David Thorpe

*"Let's get out of these wet clothes
and into a Dry Martini"*
Robert Benchley

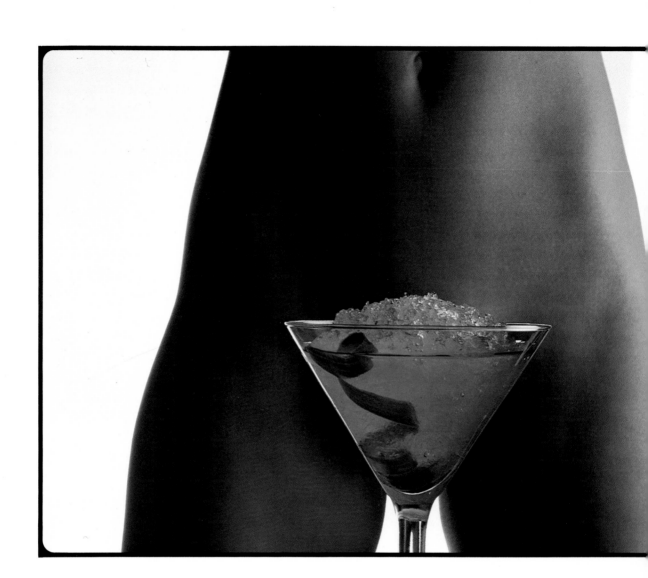

ARISE MY LOVE

AFor some reason, the cocktail has become established as the world's most suggestive drink.

Beer is hearty. Wine is taken seriously. But cocktails are definitely frivolous, hand-on-the-leg-under-the-table drinks.

The mere act of ordering a Bosom Caresser, for instance, or an Ankle Trembler, is a fair indication that the next few hours will not be spent discussing philosophy.

The ideal cocktail, being as it is a glass of alcoholic foreplay, should be seductive to the eye and stimulating in the mouth.

Apart from that, there are no restrictions, and virtually no limits to what a fertile imagination and a well-stocked bar can achieve.

The most unlikely ingredients can be combined, and even more unlikely names given to the result. Here, for instance, we have Arise My Love, so called because of its restorative powers at the end of a hard day and the beginning of a strenuous evening.

Put a teaspoon of Crème de Menthe into a pre-chilled glass, and fill with champagne. The result is almost luminous, which makes it a particularly good drink to serve in dimly-lit boudoirs where a darker drink could easily get lost.

BETWEEN THE SHEETS

To become really proficient at making cocktails, you must first master the arts of squeezing, shaking and straining – three essentials for anyone attempting to conquer Between The Sheets.

SQUEEZING

The better your ingredients are, the better the final drink will taste. This is especially true for recipes that require lemon juice – there is no substitute for a plump, fresh lemon, squeezed at the last minute.

SHAKING

Shaking cocktails is not quite as simple as a professional barman makes it look. The ice should go in first, so that the ingredients are cooled on their way down, and the alcohol last. (This helps you avoid putting a double dose of alcohol in, or forgetting it altogether.) And you should never fill the shaker up to the brim; leave a little room so that everything can mix easily.

STRAINING

It's worth buying a proper strainer which fits over the mouth of your cocktail shaker and prevents unwanted objects from getting into your glass. Nothing ruins the romantic moment of that first sip as effectively as a cherry stalk up the nostril, or a bout of choking brought on by a lemon pip.

And now, with shaker and strainer at the ready, take the juice of a quarter of a lemon, half an ounce of light rum, half an ounce of brandy, and half an ounce of Triple Sec. Shake well with plenty of ice, and strain into pre-chilled glasses.

With this, as with most cocktails, it is very important to stick closely to the suggested measures. Too liberal a hand with the Triple Sec, and you're likely to end up under the table instead of Between The Sheets.

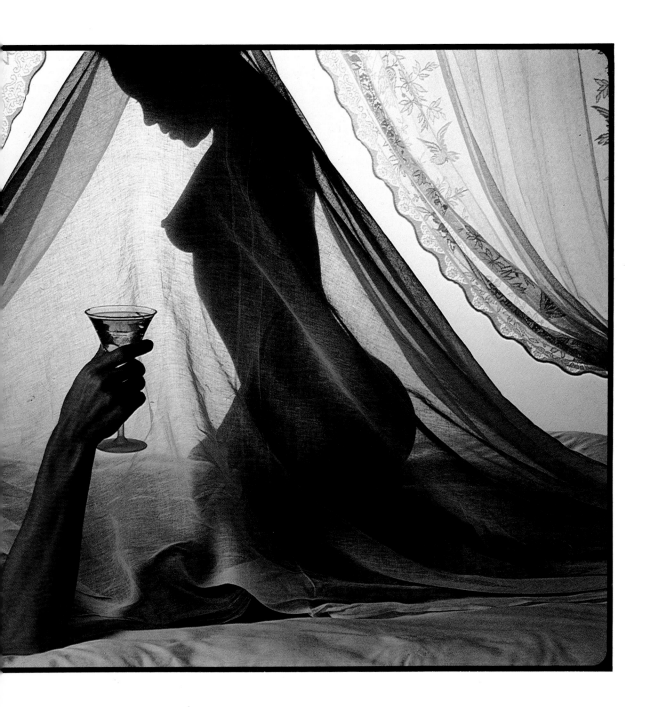

COBBLERS

For those of you in search of a health-giving, vitamin-packed drink that will put you flat on your back, the answer's a Cobbler.

Cobblers are large and innocent-looking, decorated with fruit and sipped through straws. Harmless and nourishing, you think to yourself as the first one goes down. Two or three Cobblers later, and you will notice that some of your guests are beginning to go down, sucking contentedly on highly alcoholic maraschino cherries as they slide to the floor.

The reason, of course, is that beneath the fruity exterior lies enough hard liquor to make your liver wince. This recipe for a Cherry Cobbler will give you an idea of what we mean.

Fill a large glass with chipped ice. Add an ounce and a half of gin, an ounce and a half of cherry brandy, half an ounce of Crème de Cassis, a teaspoon of sugar, and half an ounce of lemon juice. Stir until the sugar dissolves and the concoction stops smoking, and then add a slice of lemon and a cherry or two.

There are several other Cobblers, ranging from Amaretto to whisky. Most of them have the deceptive appearance of a floating fruit salad.

All of them are potentially lethal. Handle your Cobblers with care!

DIRTY MOTHER

DSay what you like about the people who invent cocktail names, but you can never accuse them of restraint or good taste. For every one poetically named cocktail there are three Bodice Rippers, Groin Bangers or Frothy Screws.

Not even Mother, that pillar of society and mainstay of family life, has escaped the unwholesome attentions of these monsters of depravity. And who knows where they will turn next? Is nothing sacred? Can we expect to see cocktails named after politicians, heads of state, or even those godlike figures, television personalities? The mind boggles.

Anyway, here's how to make a Dirty Mother.

Take a short, fat glass. Almost fill it with crushed ice, then top up with three and a quarter ounces of brandy and three quarters of an ounce of Kahlua. For a Dirty White Mother, use a taller glass of crushed ice, and fill with an ounce of brandy, an ounce of Kahlua, and an ounce of double cream. For a Dirty Grandmother, use very old brandy. And for a Dirty Mother-in-Law, use your imagination.

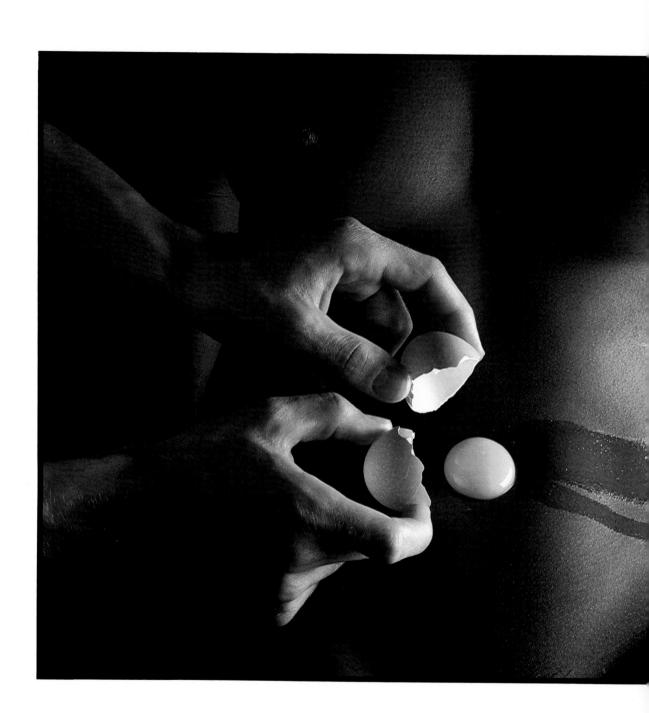

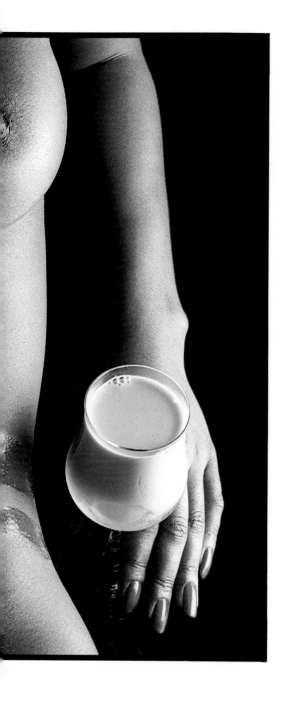

EGGNOGS

E The original eggnog recipe dates from about 1775, and goes something like this: into a large bucket, pour as much brandy or rum as you can lay your hands on. Place the bucket beneath a neighbouring cow, and milk until the bucket is full.

Add eggs. Stir with an axe handle.

It is not always easy to find cows and axe handles nowadays, but modern science has come to the rescue in the form of the pre-mixed, non-alcoholic eggnog to which you add your chosen liquor. For the most basic eggnog, add twelve ounces of brandy to two pints of eggnog mix, and sprinkle grated nutmeg on the top. There are many alternatives to brandy: rum, whisky, cider port, sherry – all of them will produce the same effects of a slightly glazed eye and a faint trace of froth at the lips.

Eggnogs are traditionally only drunk during the Christmas season, and are best dealt with in front of an open fire while you and your beloved are waiting to see what Santa is bringing you down the chimney,

In our case, it's usually a hangover.

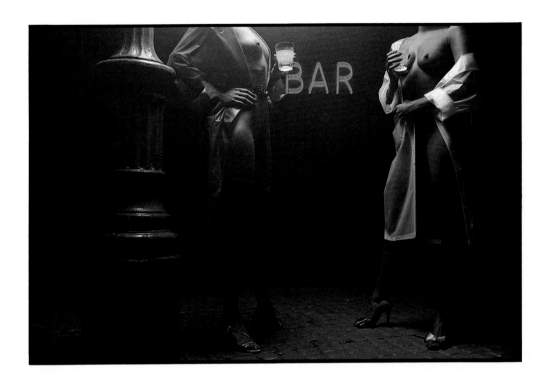

FOGGY DAY

F Some cocktails should be drunk in bars. Others in bed. But this one calls for a large, steam-filled bathroom.

There is something about the icy combination of gin (one and a quarter ounces) and Pernod (half an ounce) that is marvellously refreshing when external conditions are moist and muggy.

And there is something delightfully self-indulgent about drinking in the bath, specially when there are two of you.

So settle yourselves comfortably, with a jugful of reinforcements by your side, and raise your glasses in a toast to good clean fun.

GAUGUIN

G Thirsty work, painting. After finding your model, reassuring her mother that your intentions are artistic, and concentrating on naked flesh all day long, a man needs a drink.

It is unlikely that Gauguin himself ever tasted the cocktail named after him, but don't let that put you off. It is a very pleasant drink, and definitely encourages a rush of paint to the brush on a hot summer's day.

For each drink, you will need two ounces of light rum, half an ounce of passion fruit syrup, half an ounce of lemon juice, a quarter of an ounce of lime juice, and a glassful of crushed ice. Put it all in the blender, and blend at slow speed for 10 to 15 seconds. Serve in a champagne glass, decorated with a cherry.

Two or three of these will set you up for a lively game of Artists and Models, followed by a nap.

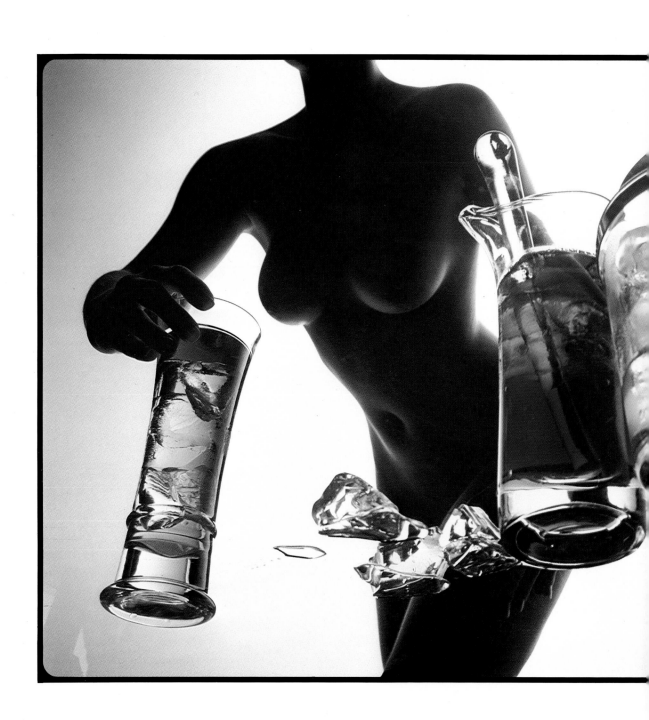

HIGHBALLS

HYou may have been clutching highballs at parties for years without being aware of it; the highball is merely a generic name for a small amount of something strong with a larger amount of something weak. A gin and tonic is a highball. So is a Scotch and water. Strictly speaking, highballs should be served in tall glasses, otherwise they are relegated into the second division and become lowballs. (We have never heard anyone brave enough to order them by name, but our bartender assures us that the lowball is a genuine, government-approved classification.)

A simple matter, you may think, to make the perfect highball, but there are a few basic rules to follow. The glass should be able to hold at least eight ounces, and it should have a heavy bottom.

This is more satisfying in the hand, and less likely to slide off the bar. The ice cubes should be hard, clean, and free of perspiration. The mixer should be pre-chilled.

Depending on the thirst and general depravity of your guests, the amount of alcohol will vary from one and a half to two ounces per drink. Anything less is a softball.

ITALIAN STALLION

Most cocktails are designed to be drunk before eating – to stimulate the gastric juices, to make the tongue pleasantly loose and the guests pleasantly tight. But for some years now there has been increasing activity at the other end of the meal in the form of rich and sinful drinks to be taken after, or instead of, the dessert.

The Italian Stallion is one of them.

The Italian part of the name comes from the liqueur used as a base, which is Galliano.

Legend has it that Casanova used to take a nip of this instead of cocoa before going to bed, which is probably where the stallion part comes from. (Although a less romantic explanation of the name is that the drink has a kick like an untipped Italian waiter.)

Whatever the derivation, an Italian Stallion will bring a whinny of pleasure from anyone with a sweet tooth, and it's a lot easier to make than a good dessert.

Take three quarters of an ounce of Galliano, three quarters of an ounce of Crème des Bananes, and one and a half ounces of double cream. Blend with crushed ice and serve in a wine glass, while humming an Italian love song.

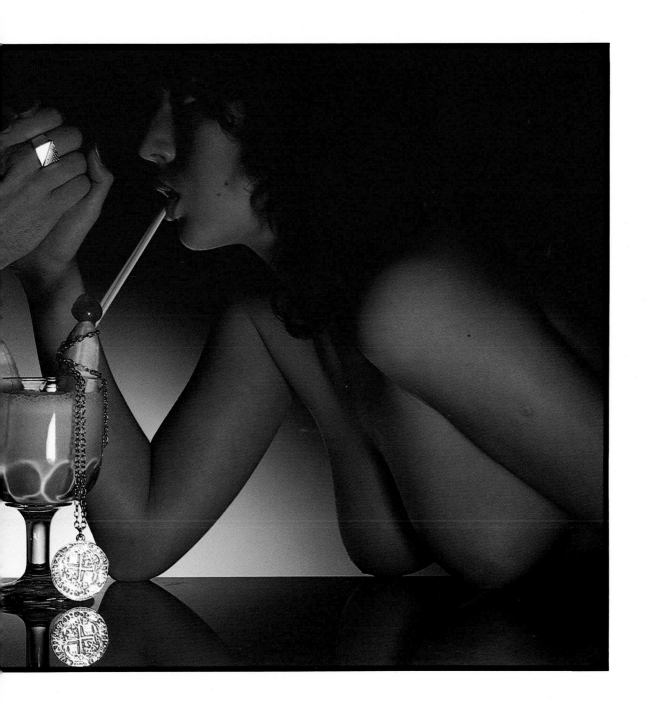

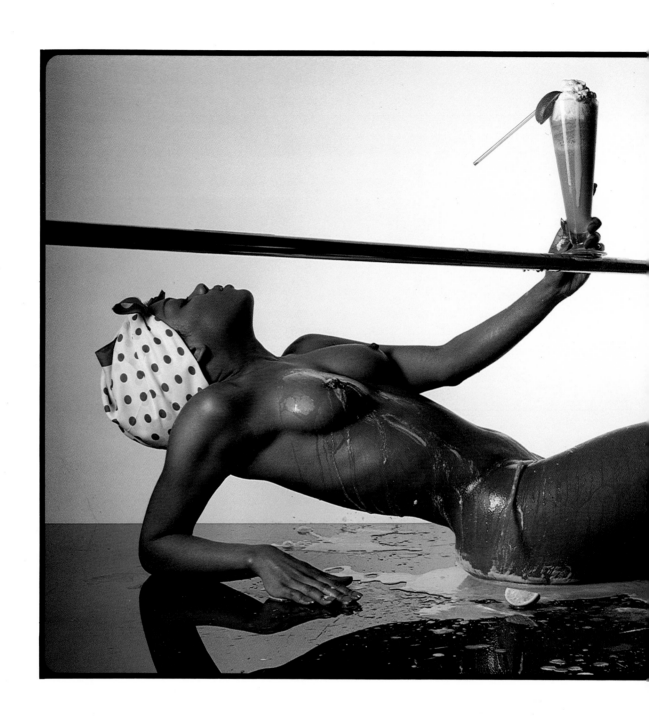

JAMAICAN SHAKE

J A fine training drink for amateur limbo dancers, as it lowers the body's centre of gravity, induces a feeling of elasticity in the legs, and numbs the upper portion of the head. (A blessing if you should fall backwards in mid-bend.)

Ideally, you should take your Shake on to the beach, and drink it under the tropical sun. Failing that, borrow a sunlamp and do the best you can.

Start with one and a quarter ounces of rum.

Add a scoop of vanilla ice cream, an ounce of pineapple juice, a quarter of an ounce of Grenadine, and an ounce of double cream.

Mix in a blender with crushed ice, remove all restrictive clothing, and serve.

Do not attempt to drink and limbo at the same time. The rum goes straight to the brain cells, and it is several days before you can regain an upright position.

KISS IN THE DARK

Take care when ordering. Depending on your sex and disposition, asking your host for a Kiss In The Dark could lead to social complications when all you really wanted was a drink.

It might be safer to memorize the recipe instead: three quarters of an ounce of gin, three quarters of an ounce of cherry brandy, and three quarters of an ounce of dry vermouth, stirred with ice and strained into the glass.

The flavour is distinctive, and so is the smell; if you happen to mislay your partner at a crowded party, all you have to do is follow your nose. And if that doesn't work and you're caught kissing someone else, remember what Groucho Marx said when his wife surprised him with another woman: 'I wasn't kissing her. I was whispering into her mouth.'

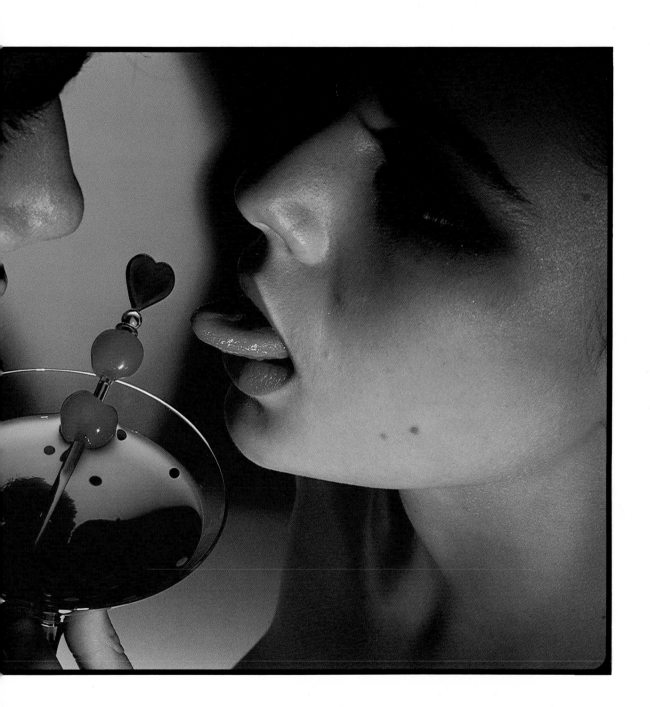

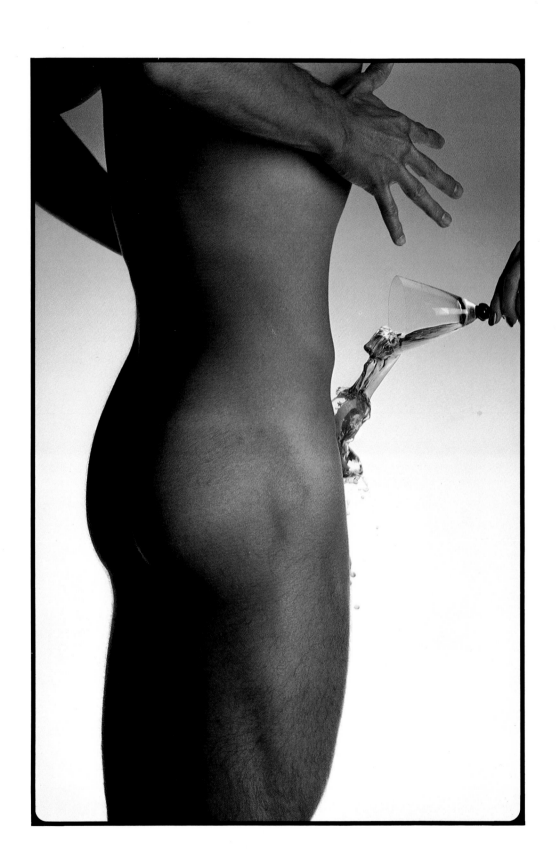

LOOK OUT BELOW

L The pirate captains who roamed the Caribbean used to fortify their prisoners with this powerful concoction before making them walk the plank. (In those days, 'just a splash' had a completely different meaning.) One drink was usually enough to send the victim wobbling on his way, spurred on by good-natured prods from a cutlass and shouts of 'look out below' to the waiting sharks.

Much to the disappointment of the world's shark population, this custom has disappeared. But the drink is still with us, and it's as strong as ever. Its base is 151°-proof rum, which has almost twice the alcohol content of ordinary rums. One and a half ounces of this, the juice of a quarter of a lime, and a teaspoon of Grenadine, shaken with ice and strained into a glass of ice cubes, and there you have it.

A drink which will see you through interviews with the bank manager, visits to the dentist, appearances at the Old Bailey, or a wet Sunday afternoon.

MARGARITA

MYou may now take a short break from your maraca lessons while we study the anatomy of the Margarita. The main ingredient is distilled from a plant called the Agave, which grows in the area around the Mexican town of Tequila.

Nothing else is genuine tequila, no matter what it says on the label.

Supporting the tequila, or disguising its taste, depending on your point of view, is Triple Sec, a colourless, orange-flavoured liqueur.

The third, and most important, ingredient is the ritual dance performed by whoever is actually making the drink.

First, you rub the rim of the glass with the rind of a lemon or lime. You then dip the rim in salt. Next, shake an ounce and a half of tequila and a half an ounce of Triple Sec with ice (using the shaking motion learned in your maraca lessons), and strain into the glass.

The result will bring tears to a gringo's eyes.

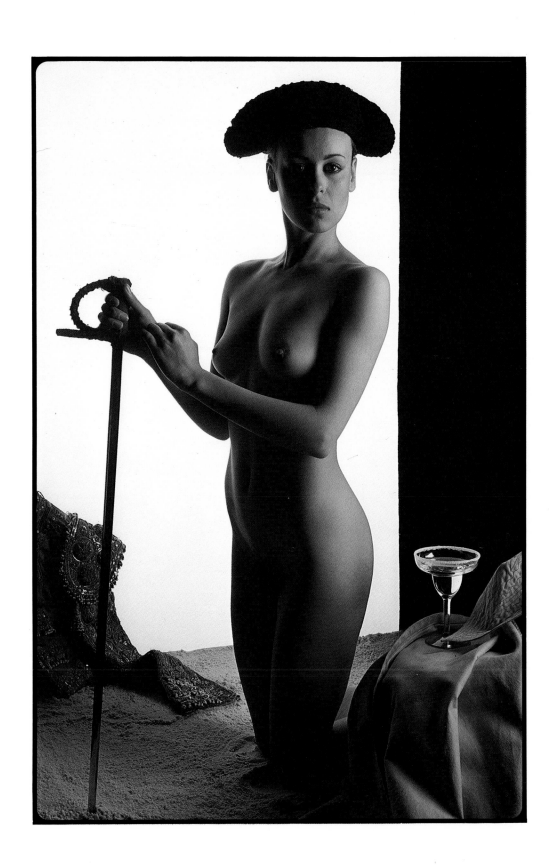

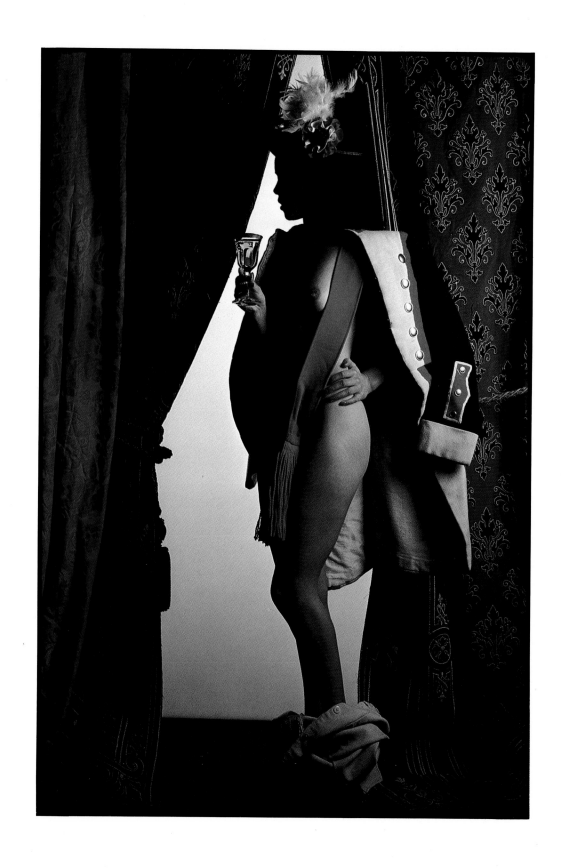

NAPOLEON

NOne of the mysteries that has puzzled historians for many years is why Napoleon seemed to have one hand permanently anchored under his coat.

Various theories have been advanced, from itching ribs caused by woollen underwear to protecting the Napoleonic wallet from pickpockets. Now at last the truth can be revealed.

Liking his drink, but being anxious not to set a bad example to his troops, Napoleon kept his glass under cover on all public occasions. Not even Josephine discovered his secret until one night she greeted Napoleon with an enthusiastic hug as he returned to his tent.

This led to his famous but usually misquoted remark. In fact what he said as she embraced him was, 'Not so tight, Josephine', for fear that she would spill his drink all over his cummerbund.

So much for the man. Now for the cocktail. To make a Napoleon, you need two ounces of gin, half a teaspoon of Curaçao, and a half teaspoon of Dubonnet. Stir with ice and strain into the glass. Voilà!

OLD-FASHIONED

O Here is a shameful example of sexual discrimination in the cocktail world.

There are two versions of the Old-Fashioned. For the masculine version, you stir half a teaspoon of sugar, two dashes of Angostura bitters, and a teaspoon of water in a pre-chilled glass until the sugar dissolves. Fill the glass with ice cubes, and add two ounces of American blended whiskey. Stir well. Twist lemon peel over the top, then drop the peel into the glass.

For the feminine version, you go through exactly the same process, and then reach for the fruit bowl. Slices of orange, slices of lemon, cherries (probably skewered with those dreadful little paper umbrellas on sticks) – almost anything goes. The reason for this wretched excess, so we're told, dates from the days when women wore cocktail hats decorated with clusters of imitation fruit, and it was chic to have a matching drink.

The fashion ended in tragedy. One lady, after several drinks too many, became confused and swallowed two imitation cherries by mistake. She was rushed off to hospital with hat poisoning.

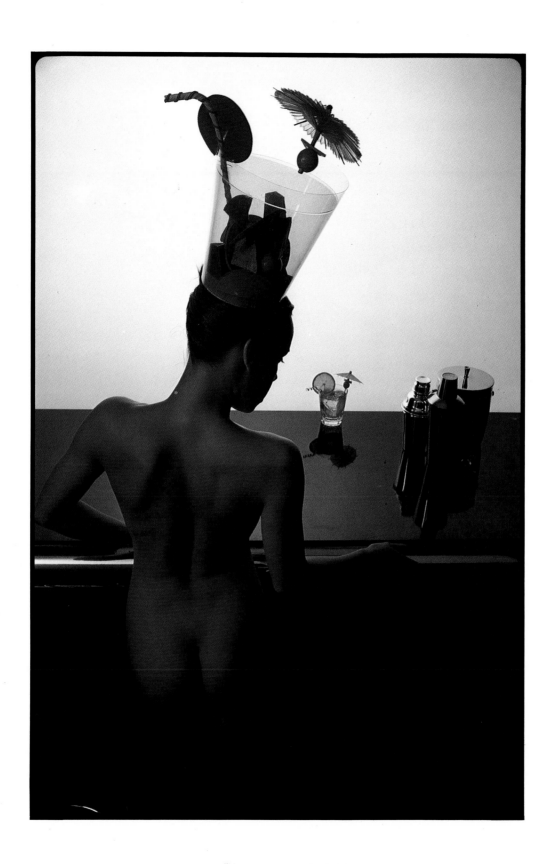

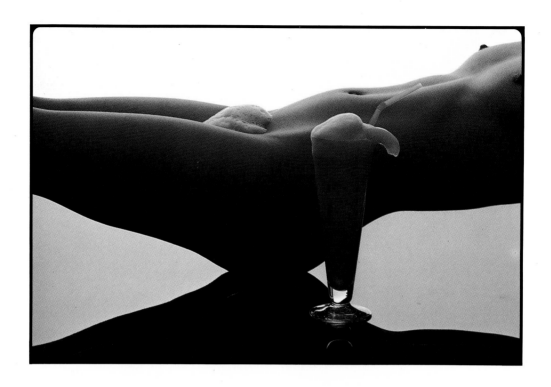

PEACH BLOW FIZZ

P The Fizz family of drinks originated in the Deep South, along with Mint Juleps and Kentucky Colonels.

The recipe was devised as a pick-me-up for plantation owners who had spent a strenuous morning chasing young women around magnolia bushes. It was later adapted for the feminine taste, with shocking results.

Daughters of respectable families, inflamed by the new drink, were actually seen chasing plantation owners. The South never recovered.

Of all the Fizzes, the Peach Blow is our favourite. You take the juice of half a lemon, half a teaspoon of fine sugar, an ounce of double cream, two ounces of gin, and a quarter of a fresh peach. (This must be peeled, or you'll end up with a peach Blow Fuzz.) Shake with ice and strain into a tall glass of ice cubes. Fill with soda water and stir.

Save the peach for later. It makes a marvellously intoxicating suck.

QUICK CRUSH

Q Nothing could be easier. Take a handful of ice cubes, crush them in the blender, and almost fill the glass with crushed ice. Top up with a generous measure of alcohol.

Use vodka for a Russian Crush, Pernod for a French Crush, Drambuie for a Scottish Crush, and so on. The list is as long as your bar.

Our photograph shows the old, traditional method of crushing ice (similar, in its way, to treading the grapes for winemaking). Alas, like many picturesque customs, this has largely disappeared. You will only find it performed nowadays in the more primitive regions of Soho, where many ancient skills still flourish.

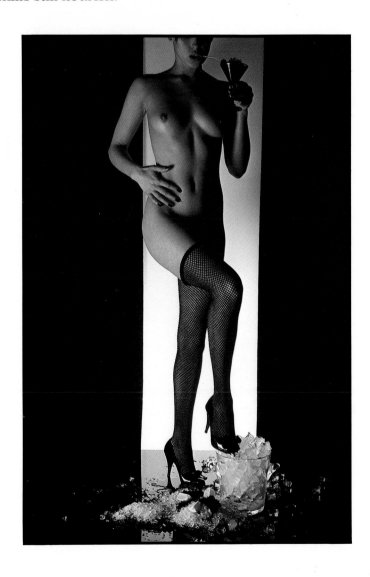

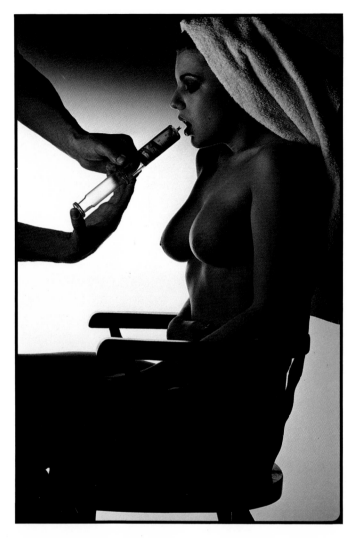

RUM FIX

RWe had always thought that 'having a fix' was a modern expression until we found this surprising passage in an obscure Victorian novel:'*Ashby*', said Sir Nigel to his butler. '*I am plagued by the heat. Bring me a fix. And one for the vicar as well.*'

What had we stumbled upon here? Dissolute behaviour among the Victorian gentry? Men of the cloth indulging in exotic substances?

We turned the page, eager to see what kind of forbidden pleasure the butler was going to serve.

It turned out to be nothing naughtier than a drink, the ingredients of which are 'fixed' in the glass itself before adding ice. Still, the vicar enjoyed it, and maybe you will too.

To make your fix, put the juice of half a lemon, a teaspoon of fine sugar, a teaspoon of water, and two and a half ounces of rum into a tall glass. Stir, fill with crushed ice, and add a slice of lemon.

SALTY DOG

S There are two breeds of Salty Dog: the first is made with vodka, and is sometimes known as a Salty Borzoi, while the second is made with gin. Either one is guaranteed to make your tail wag.

It is also an agreeable way of topping up your supply of Vitamin C, which is Nature's protection against hardpad, distemper, and the common cold. Mix one and a half ounces of gin or vodka with five ounces of grapefruit juice, and add a quarter teaspoon of salt. Pour into a tall glass over ice cubes and stir well.

You can now practise some elementary obedience training. After a few Salty Dogs, even the most undisciplined guest will sit, lie down, and roll over on command.

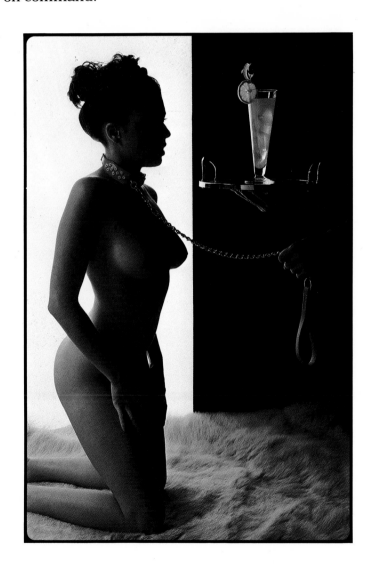

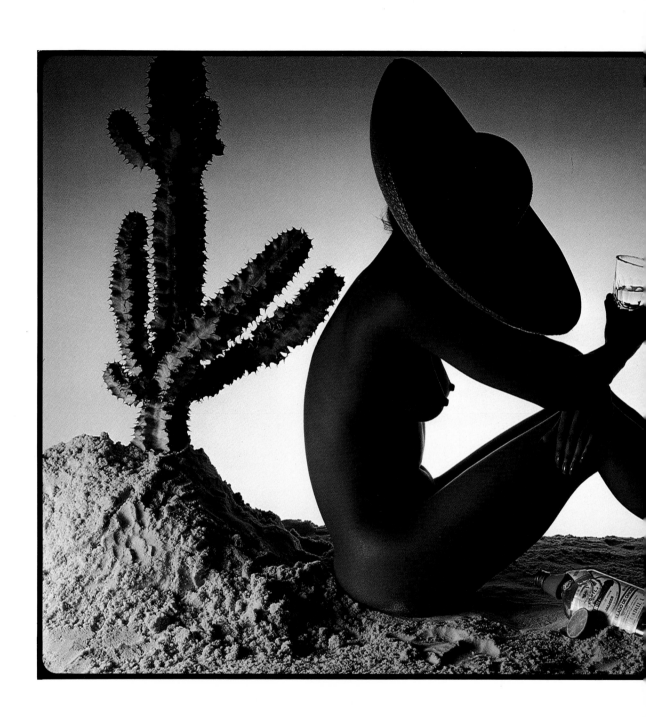

TEQUILA HOOKER

T This is a complicated drink requiring physical co-ordination of a high degree, and should not be attempted too late in the evening.

There are three distinct actions to be carried out.

1. THE LICK

Place a pinch of salt on the back of the hand, and lick it.

2. THE SWALLOW

Take a shot glass (about one ounce capacity) of tequila, and swallow in one go.

3. THE SUCK

Before the tequila has had time to reach the central nervous system, take a wedge of fresh lemon or lime, and suck vigorously.

The faster you can perform these three steps, the better your Hooker will taste, but be careful not to confuse the sequence. Swallowing when you should be sucking can lead to choking fits and complications, and you will get no sympathy when you complain that your Hooker went down the wrong way.

UNION JACK

Unlike most cocktails, which can be drunk in a sitting or reclining position, the Union Jack is traditionally taken while standing to attention, the back ramrod-straight, and thumbs in line with the seams of your trousers.

On the command 'load', fill your shaker with three quarters of an ounce of sloe gin, one and a half ounces of ordinary gin, and half a teaspoon of Grenadine. Shake with ice and strain into a glass.

On the command 'aim', elevate the glass to a position two inches north of the lips, keeping your elbow at full cock and your arm at right-angles to your body.

On the command 'fire', place glass to lips and tilt.

Fall out.

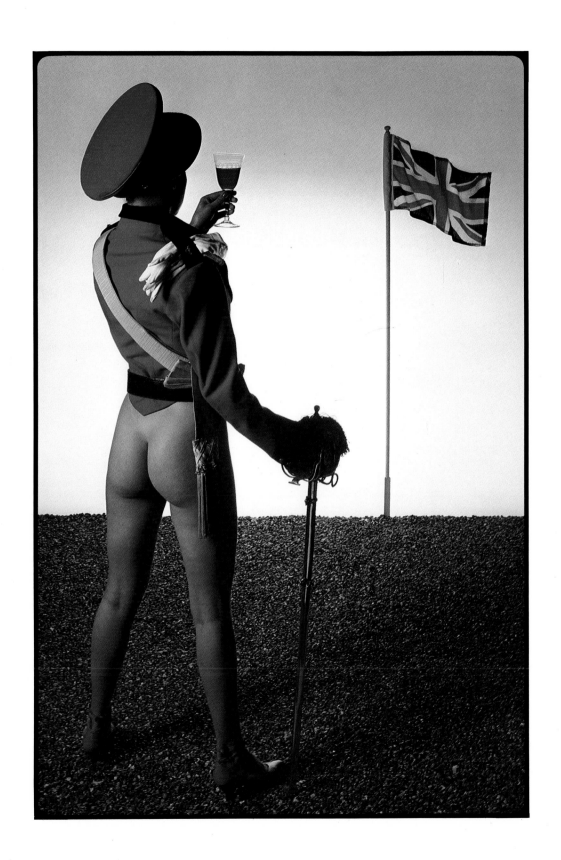

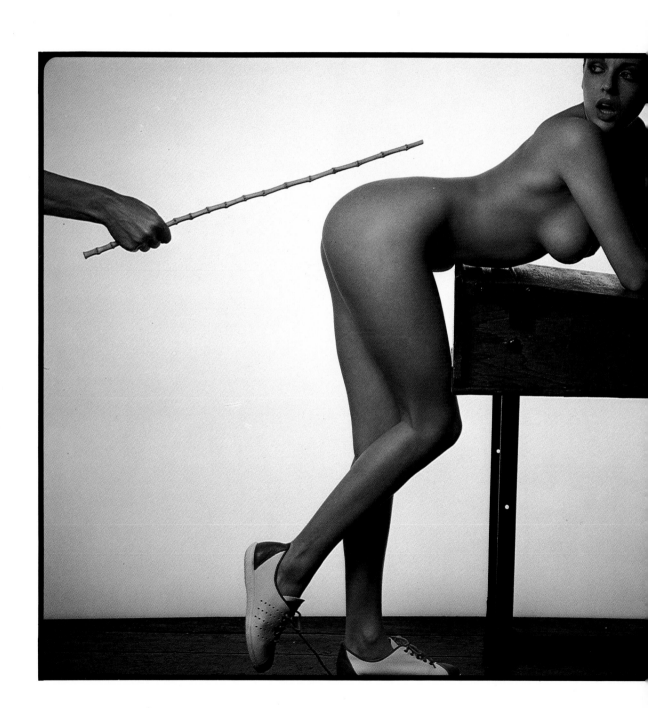

VERBOTEN

V At last, we thought to ourselves as we rushed to get our jackboots and uniforms, a German cocktail. Decadent bars in Berlin! Strict waitresses! Marlene Dietrich!

Closer investigation of the recipe, however, revealed that this drink is about as German as a gin and tonic, although a little more exotic.

The name, doubtless invented by a bartender called Fritz, comes from Forbidden Fruit, which is one of the ingredients. So far as we know this is not native to Germany, but more likely to be found in the Harrods' Food Halls. Apparently it grows in cans.

Putting on your cocktail führer's hat, proceed as follows: one tablespoon Forbidden Fruit, one tablespoon orange juice, one tablespoon lemon juice, and one and a half ounces of gin. Shake with ice and strain into glass. Add a brandied cherry. To create a truly Teutonic mood, play something by Wagner and bully the smallest person in the room.

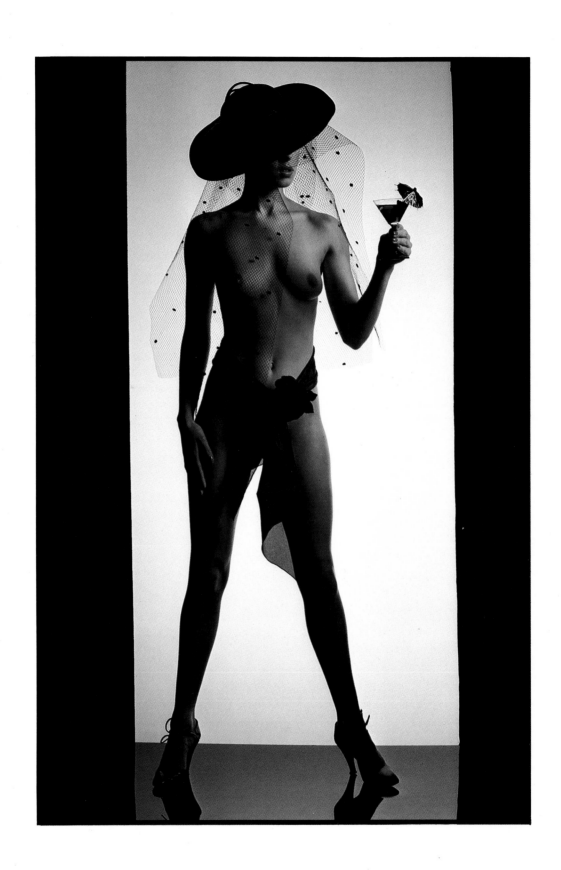

WIDOW'S KISS

WFirst concocted by an alcoholic funeral director as a mourning pick-me-up, the Widow's Kiss is powerful stuff.

The first ingredient is an ounce of brandy. (Rich widows may prefer very old cognac.) Now add half an ounce of yellow Chartreuse, half an ounce of Benedictine, and a dash of bitters. Shake with ice and strain into a glass.

Remember to raise your veil before drinking.

X-RATED

X Of all the improbable names given to cocktails, this one takes the prize. It is not, as you see from the recipe, a wildly erotic mixture. What is most important here, though, is to be correctly dressed before you pick up your glass.

Whenever two or more are gathered together for X-Rated cocktails, everyone taking part *must* wear a grubby raincoat and a furtive air. The rules of dress regarding what goes under the raincoat are, shall we say, more elastic. In fact, anything from complete nudity to those curious garments advertised in surgical supply catalogues is acceptable providing you can sit down without injury.

At a pre-arranged signal, all the raincoats must be removed. This will break the ice at any party, and possibly some of the chandeliers as well.

Here's the recipe:

Place half an ounce of white rum in a shaker, add half an ounce of blue Curaçao, a dash of lemon juice and a touch of egg white. Shake well, pour into a champagne glass and top up with champagne.

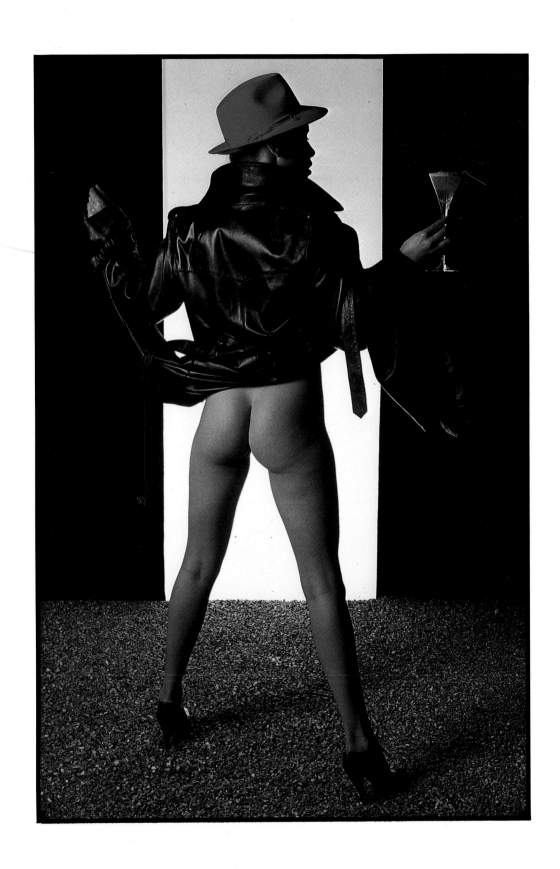

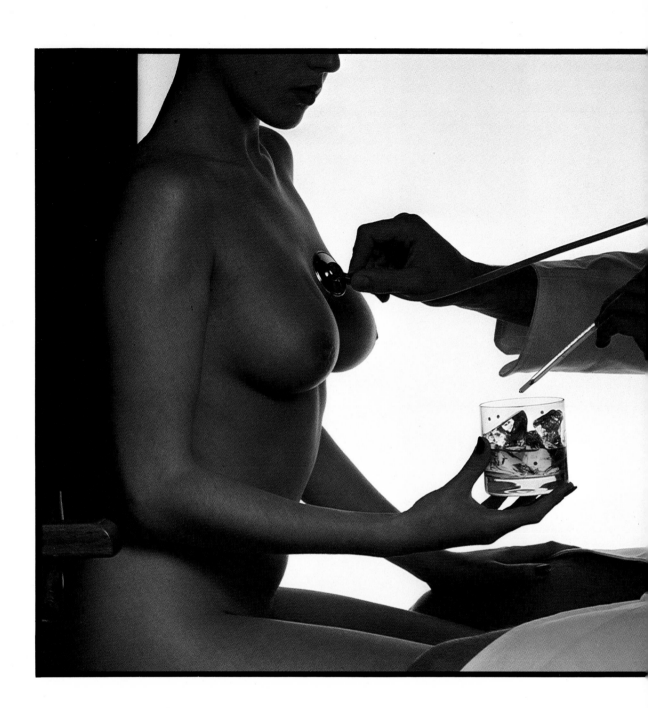

YELLOW FEVER

Y The next time your doctor tells you to rest, keep warm, and take plenty of liquid, follow these simple instructions. Mix three quarters of an ounce of yellow Chartreuse with three quarters of an ounce of cognac in a glass. Add ice cubes.

Take your companion (who need have no medical qualifications apart from a good bedside manner) into the bedroom and conduct a very thorough physical examination.

Repeat the treatment as necessary. Under no circumstances allow visitors.

ZOMBIE

Z One of the most complicated recipes, and one of the most potent drinks. You'd better make a batch of them while you can still see straight.

Take an ounce of unsweetened pineapple juice, the juice of one lime, the juice of one small orange, a teaspoon of fine sugar, half an ounce of apricot brandy, two and a half ounces of light rum, an ounce of dark rum, and an ounce of passion fruit syrup.

Put all these in a blender with half a cup of crushed ice. Blend at low speed for 60 seconds and strain into a frosted glass. Decorate with a cherry and a slice of lemon.

Now float half an ounce of 151°-proof rum on the top, and garnish with a sprig of fresh mint dipped in powdered sugar.

Two of these and you'll be under the table. A third, as Dorothy Parker once said, and you'll be under the host.

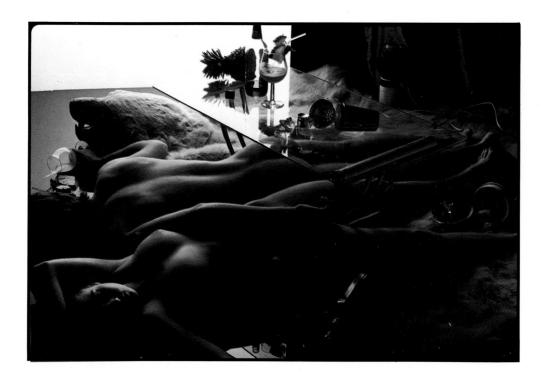